LIVING UTOPIA
AND DISASTER

2007

Alberta Biennial of Contemporary Art

Curated by Catherine Crowston and Sylvie Gilbert

ART **GALLERY OF ALBERTA**

The Banff Centre
inspiring **creativity**

© Art Gallery of Alberta 2007

ISBN: 978-0-88950-146-1

Editors: Catherine Crowston and Sylvie Gilbert
Catalogue Design: Pamela Clark
Exhibition Logo Design: Jeff Sylvester, Pilot Design, Edmonton
Photography: M.N. Hutchinson
Printing: Douglas Printing, Edmonton

TABLE OF CONTENTS

THE 2007 ALBERTA BIENNIAL OF CONTEMPORARY ART: LIVING UTOPIA AND DISASTER features the work of 22 Alberta artists co-presented by the Art Gallery of Alberta and the Walter Phillips Gallery. In its 6th incarnation, the *Alberta Biennial of Contemporary Art* is an investigation of the dual themes of Utopia and disaster within the context of Alberta and its relation to the world environment.

The works in the exhibition raise questions about the paradoxical nature of our living experiences. They comment on the various ambiguous, competing and sometimes oppositional communities that we traverse and exist within. When wildly optimistic, we can become completely rapt in the possibility of a longer, fuller and more affluent existence while being concurrently disquieted by events, economics and beliefs that threaten to dramatically endanger such fulfillment. The works in the exhibition act as discrete reminders that hopes are often matched with impeding catastrophe, actions with adversity, and that Utopia is mostly built on disaster. As economic achievements are boasted and celebrated, misfortunes that have made such wealth possible are minimized or even dismissed. The exhibition does not subscribe to one world view or the other, but rather presents them as almost inevitable, yet paradoxical, partners.

This publication includes a special contribution by Donna Brunsdale and Gary Burns. Their text is intended to expand the theme of the exhibition itself, and proposes another way of imagining the possibilities of living Utopia—and disaster—in contemporary Alberta.

As a special celebration of one of Alberta's senior artists, the *2007 Alberta Biennial of Contemporary Art* includes a survey exhibition of the work of Alex Janvier, organized and presented by the Art Gallery of Calgary. Curated by Donna Wawzonek, the exhibition traces Janvier's work from the 1970s to the present, and follows developments and changes within his signature style.

Catherine Crowston
Sylvie Gilbert

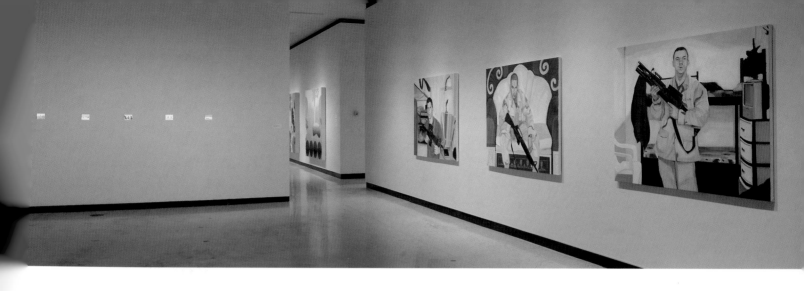

JUNE 23 - SEPTEMBER 9, 2007
ART GALLERY OF ALBERTA

OCTOBER 26, 2007 - JANUARY 6, 2008
WALTER PHILLIPS GALLERY

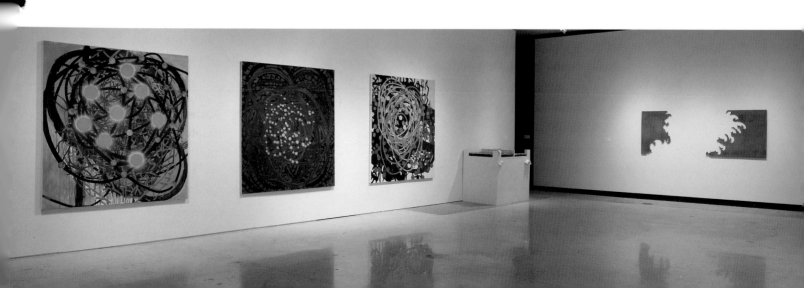

"Charming and Desirable"

by Donna Brunsdale and Gary Burns

Shmorgasburb

Gillian

So happy to have it. Months of looking anxiously, making offers never quite high enough, where does everyone get all this money? But now we're here. A one and a half, open plan, home office off the entrance. Big enough yard, nothing in it yet, but a couple of trees will improve it. Some black in every room, like the word "eat" spelled out in the eating area. Clever and trendy. A great neighbourhood, close to amenities, lots of other children.
Space out here.
Phew.

Innerdale

Eve

We have arrived, no insufferable car culture for us, walk everywhere, a sense of community, history. "One of the most desirable." Older character home, the reno was hell, just as everyone warned, but the new kitchen is worth it. A clever blend of old and new, eclectic is the term, I believe. Difficult balance to achieve, still working on it, actually.
But proximity to shops, restaurants, cultural outlets, my god.
Ha.

Gillian

It's so peaceful, really peaceful. Occasional lawnmower. Not even any birds chirping, that always drove Will crazy in the Spring. Nothing to do but sit back and relax, when you get home. Went for a walk last night, really quiet. Except for that teenager and his souped-up car, those young people, they're gonna ruin their hearing with that music so loud. Oops, I sound like my parents. That one house really isn't keeping things up. But live and let live, right?

Eve

It's a very eclectic neighbourhood, we like that energy, young people, old people, rich, poor. More poor than you'd think, with the prices the way they are. I suppose people invest, rent them out. How else can young people afford it? Walked to a restaurant for dinner, so close. Pretty good Vietnamese, wouldn't use the bathroom again though, just disgusting. Don't restaurants know that it bothers people? Kind of surprised by the clientele also, with the prices around here. But so nice just to walk home, no worry about too many drinks!

Gillian

Well, that was quite the drive tonight. Didn't know the traffic would back up like that. I guess once a lane gets shut down… But, once home, what a relief. Out of milk though, just forgot. We did paper/rock/scissors to see who would get back in the car, fun, silly. Billy had never seen it before, wouldn't stop. So cute. Those teenagers really drive too fast, maybe Will could speak to them sometime.

Eve

This is heaven. People are primarily so friendly. I'm just not sure about that woman two doors down. Perhaps she's just shy. Or maybe she's deaf, no I think she saw me, but maybe she looked away as I waved. But just walking to work, how wonderful is that. Exercise and transportation all in one. I bought new shoes that make all the difference. Need to break them in more, talk about blisters. But no more driving for hours every day. And no huge lawn to mow. I think we'll go to a film tonight!

Gillian

We met some neighbours, can you believe they have a boy close to Logan's age! This is working out better than we hoped. And really, that mall has everything, even restaurants. We're gonna all go one night, Jenny's or Jerry's or what ever it's called.

Really kid-friendly. Maybe Logan and Joshua can have sleepovers sometimes. The boys sure got up to crazy antics. I guess that's their age, they like being goofy like that, although I've never seen Logan do that before.

Eve

I so enjoy the proximity to downtown. Maybe I could talk her into using unscented dryer sheets, I'm sure they exist. I swear the smell permeates the surrounding area and lingers even when she isn't doing her 15 loads of laundry. And it really does give me a headache. But it's also an insult to the world. Why do people want to smell like that? We can't have the windows open or our whole house takes on the perfume odour. It's not fair. What about the bus driver who wouldn't drive until the perfumed woman got off. And many businesses have instituted no perfume rules. It's not like I'm making this up, it's a recognized issue. I think with houses so close there should be rules about that kind of thing, perfume is pollution too.

Gillian

That restaurant wasn't that good. But then what restaurant is, they're always disappointing in some way. As long as you can get pizza and Chinese delivered, you don't need to eat out very often. It's certainly cheaper not to. As long as you can steam some veg and grill some meat you don't really have to worry about dinner. And restaurants do not mix well with little boys I can tell you that. But what was that gravy made of? Besides salt. Oh well, not haute cuisine, doesn't pretend to be! (But my god, were those instant mashed potatoes?)

Eve

What I can't figure out is what attracts the vagrant types to the neighbourhood. Steve says the river, but you don't see them there, you see them by the shops. What's the attraction? And why isn't there a decent mid-priced restaurant. I mean, how hard could

it be? The density is here, people could be making money, isn't there someone who wants to make money? But aside from that, walking around the neighbourhood, interesting houses, history, some nice gardens. Although I'm surprised there aren't more nice gardens. I suppose people are busy, busy going to the shops and restaurants! (as they say)
But I do love it here.

Gillian
It was so peaceful tonight. After a crazy day at work, then the drive, then just heaven. Quiet, calm, the big sky. I don't think I even want trees cause it's so nice to see so much sky. We all lay on the grass and looked at the sky. Logan had fun putting grass on our faces, more fun for him than us. I don't know what it is about grass on your face, it kind of makes me crazy. But it's so nice to have a family, so cozy, maybe we should have another. I love Will and Logan.

Eve
Great, had another confrontation with the neighbour, this time over their new HOT TUB! I didn't know people still bought those things. Yes, fine, if it was just a tub of water, but it comes with a huge fucking motor, which is ALWAYS ON! It's like living next to a factory. Isn't it a suburban thing? A nineties suburban thing, more to the point? And somehow they don't see the noise as an issue, as if a huge motor running all the time is just like children playing or a car driving by. Listen, your right to sit in some fetid outdoor bath-tub ends where the noise hits my ears.

Gillian
Where is everyone? I thought this was going to be a friendly neighbourhood. We go for walks every night and see no one. Joshua and parents are MIA suddenly, I wonder if I complained about the restaurant too much. Maybe they really like it there, come to

think of it, they did seem to know the menu. But how could they like it? Do some people think that's good? Did I ever think that was good? I remember how much I like canned ravioli when I was a kid, then when I ate it as a nostalgic adult it was just horrible. Christ, I insulted them didn't I. Why? Why do I do that?

Eve
This is unbelievable, the thing is on all the time, we can hear it in the house with the windows closed, not that it's remotely bearable to have the windows closed in this weather. So what now, a wall? A thick, high, wall of concrete? And of course the tension is unbearable, we don't even look at each other if we can help it, I'm not sleeping well. They're basically saying tough luck and we have no recourse. They do not care. I guess they're just so happy with their stupid fucking hot tub. I hope they get a disease.

Gillian
Another drive from hell. Jesus, can't people just drive without crashing into each other all the time? Is it that hard? Maybe it's all teenagers, cause those assholes around here sure don't seem to care. I've called the cops, they have the plate number but they won't do anything. And they're never on the freeway, wouldn't you think that would help? Okay, deep breath, all better now, make dinner, play, do the bath, read some books, try to get him to go to bed without the big fuss, oh my god.

Eve
A reprieve, they're on holidays. I know, they'll lose interest eventually, right? Once they read that article on bacterial growth (I left in the mailbox). It still is such a lovely neighbourhood and mostly enlightened. Well, half and half, no, more than half, enlightened. Maybe if I posted notices about which are weeds. And I don't notice many recycling boxes out. I'm a little surprised. But I think we'll go to a movie tonight, something with action and intrigue just for fun. Try to find a decent burger in the area.

Gillian

I heard about this traffic-calming study you can get them to do. So if I can organize that, maybe the little reckless drivers will be caught. Then it will be pretty much perfect. Logan seems agitated lately, maybe he's picking up on my worrying. I don't know what to tell him about Joshua, it shouldn't interfere with the kids' friendship but there's not much I can do about it. I'm just trying not to think about it. He'll meet someone else, so will we for god's sake. It sure is quiet, I guess people have such busy lives now. Well, look at us, so do we!

Eve

I know what they say about pesticides, but really, what harm could a little spot spraying do. And it's actually herbicide. I'll just sneak out at night, do it on the sly, then it will be done and I won't have to do it again.

Gillian

So we don't qualify for a traffic-calming study, well fuck them, we have to qualify for a study? How would they know? Maybe we could adjust to something smaller, a tighter neighbourhood, more central.

Eve

So they're home, I can tell because the industrial drone is back on and the article is now in my mailbox. Fine, let them get mysterious itches. We'll just turn up the music. No, that doesn't really work, I don't really like music that much, I'm a little embarrassed to admit. Maybe they'll move, maybe we should move, why not move farther out, have a little more land around us.

Gillian

You know, if Will can't be man enough to stand up to those fucking little brats, if he'd

rather see Logan KILLED because he can't make those teenagers in their souped-up car slow down, I guess I'll just have to put on the pants and stop them. If I have to smash their car with a hammer, slit the tires with a knife, strangle them to death…here they come again…

Eve
I just want to go for a drive, cover some distance, see things go by me in a blur, get a sense of space. Maybe if our neighbours weren't five fucking feet away, if they hadn't built infills to cover every imaginable bit of area they could possibly get away with in this fucking inner-city, location, location, location, driven market, I wouldn't feel like I was being held in a pen, and, Steve slow down, don't be a maniac, you don't have to lower yourself to their level…

Screech. Crash.

Worry-free Peace and Quiet.

Donna Brunsdale is an artist and filmmaker who has presented her work in galleries and festivals across Canada and abroad. She has taught art and film at several post-secondary institutions and has worked on other films in several capacities including acting. She lives in Calgary.

Gary Burns is a Calgary filmmaker who has been writing and directing since 1992. His films include: *The Suburbanators* (1995), *Kitchen Party* (1997), *waydowntown* (2000), *A Problem with Fear* (2003) and *Radiant City* (2006).

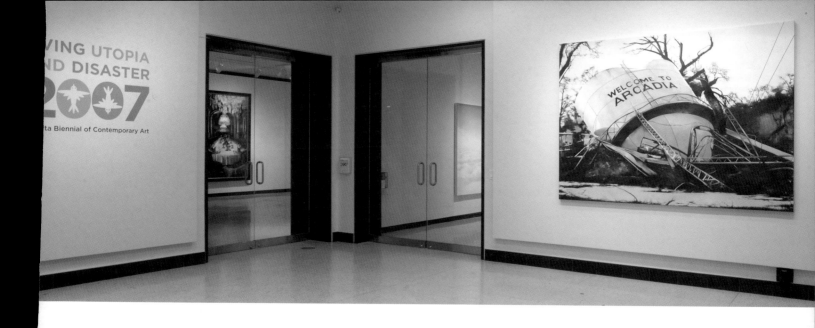

SARAH ADAMS-BACON ROBIN ARSENEAULT RICHARD
BOULET JENNIFER BOWES KEN BUERA KAY BURNS
CHRIS FLODBERG JULIAN FORREST PAUL FREEMAN ANU
GUHA-THAKURTA TERRANCE HOULE / JARUSHA BROWN
GEOFFREY HUNTER DAVID JANZEN JONATHAN KAISER
MARY KAVANAGH LINH LY ANNIE MARTIN MARK
MULLIN PAUL ROBERT LAUREL SMITH KRISTY TRINIER

SARAH ADAMS-BACON is a Calgary-based visual artist and writer. She graduated from the Alberta College of Art & Design in 2005 and has exhibited in various spaces throughout Canada. Utilizing a range of disciplines including drawing, soft sculpture, installation, video and animation, her practice explores notions surrounding collective memory, childhood nostalgia and generational identity. Her work presents the viewer with familiar, convivial images and allusions while simultaneously offering undertones of loss, disillusionment and personal grief. It is the dualism of these ends and their relation to her personal experience and perspectives that drive her practice.

Adams-Bacon is 28 years old, happily married and currently occupies her time with working, reading, writing and introducing her new little daughter to the world. Her plans for the future include raising a perfect family, maintaining a wildly successful career, acquiring lush property and a loyal dog, and vigilantly warding off irrelevance. She has never traveled overseas, but lived very close to the ocean between the ages of nine and twelve.

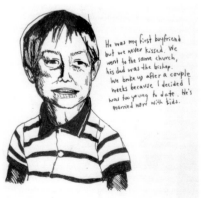

He was my first boyfriend but we never kissed. We went to the same church, his dad was the bishop. We broke up after a couple weeks because I decided I was too young to date. He's married now with kids.

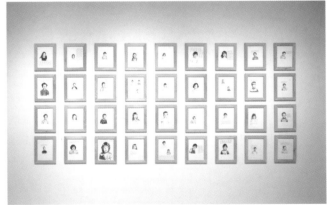

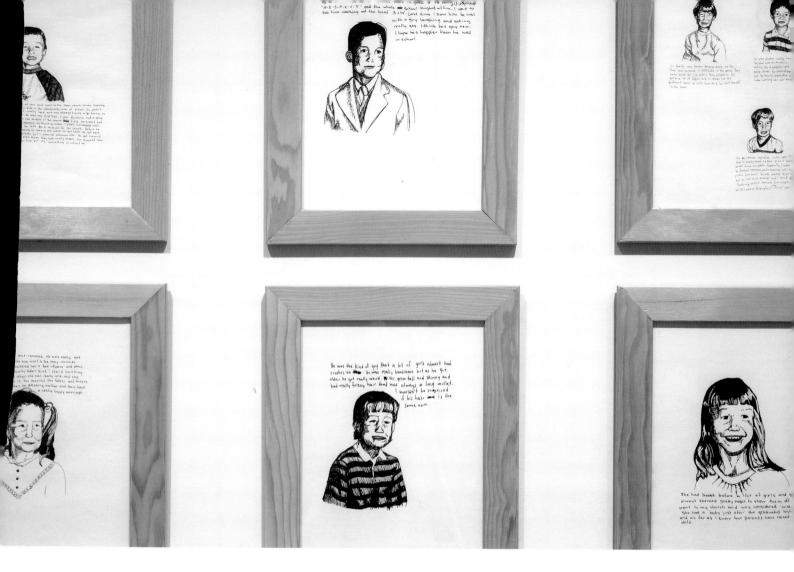

Everything was Beautiful, and Nothing Hurt (Drawing Series), 2004
Ink on paper (36 framed drawings)

ROBIN ARSENEAULT'S current research and interests lie with both the state and representation of human folly, madness, expectancy and failure. Her recent work manipulates these ideas within theatrical terms where humiliation and humor, structure and temporality, are often mixed. The role of the fool has become a central character within these narrative-based (often tragi-comic) installations, using drawing, sculpture and text. The balance between a darker side and a humoristic suggestion is where her work sits best: it is unclear if you should laugh or cry.

Robin Arseneault received her MFA from the Edinburgh College of Art, Scotland (2005), and her BFA from the Alberta College of Art & Design (1998). She has completed a residency at The Banff Centre for the Arts and been the recipient of several awards and grants from the Canada Council for the Arts, the Alberta Foundation for the Arts and Alberta Heritage. Arseneault has also worked as an instructor, curator, arts administrator, and served as the Director of the Stride Gallery, Calgary. In 2005 she wrote and published a one-act play, entitled *Monsterdom*. Arseneault has exhibited her work in the USA, Scotland, Germany, The Netherlands and across Canada. She was a recent semi-finalist for the 2007 Sobey Art Award.

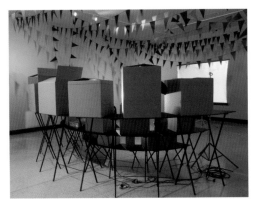 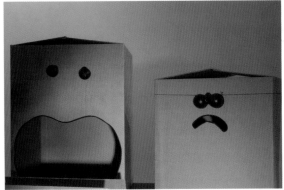

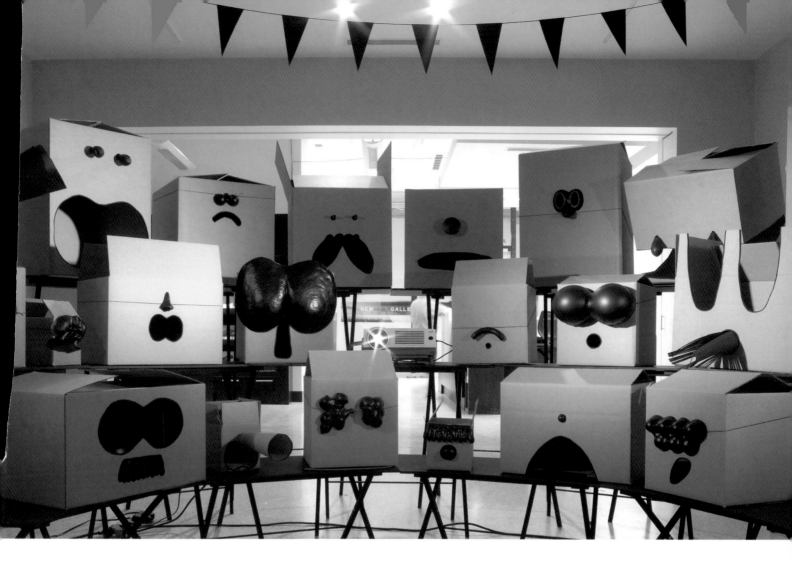

PARADOXE SUR LE COMÉDIEN, 2007
Mixed media installation (bleachers, bunting, cardboard boxes, masks)

RICHARD BOULET is a recent graduate of the MFA Drawing and Inter-Media program at the University of Alberta. His thesis dealt with mental health issues. Boulet also has a Bachelor of Environmental Studies (1983) and a Bachelor of Fine Arts (1987) from the University of Manitoba. Boulet has been working in fibre—on and off—since the late 1980s.

Boulet has been active in various art-related employment positions in different Canadian cities since his graduation. This includes work in a commercial art gallery, film and theatre set painting, as well as a teaching assistant in the art classrooms of elementary and junior high school. He is currently employed as an art technician for the Edmonton Public School Board and as an Instructor in Art and Design at the University of Alberta.

Quilt-based sewing and cross-stitching have been his primary means of creative expression for the last five years, though he continues to employ various media. The works in the *Alberta Biennial* are examples of Boulet's interest in an introspective awareness of psychological dilemmas.

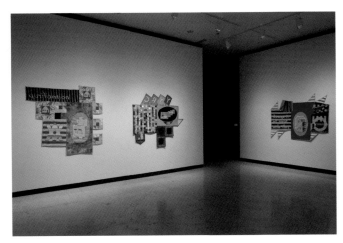

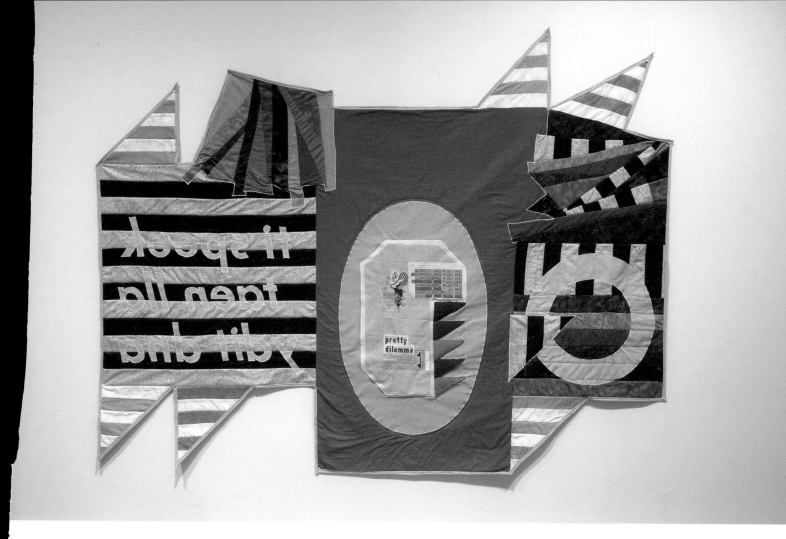

above: *KEEPS IT ALL NEAT AND TIDY*, 2007
Quilting and cross-stitch
opposite left: installation, from left to right *PURIFICATION*, 2007
Quilting and cross-stitch
CRYY, 2006
Quilting and cross-stitch
KEEPS IT ALL NEAT AND TIDY, 2007
Quilting and cross-stitch
opposite right: detail of *KEEPS IT ALL NEAT AND TIDY*, 2007

JENNIFER BOWES grew up in Lamont, Alberta. She completed her BFA in 1999, specializing in Painting and Drawing, at the University of Alberta. After spending a year teaching English in Northern Italy, she returned to the University of Alberta to complete her MFA in Drawing. Bowes is a Sessional Instructor at the University of Alberta and Grande Prairie Regional College.

Bowes is influenced by memories of her childhood landscape, but also by travel. In recent years, she has spent time in Scotland, England, Italy, Turkey and Nepal. In all of these countries, Bowes has spent the bulk of her time in rural areas, intrigued by those who live simpler lifestyles. With a growing interest in textiles, she has started to combine methods of textile work with ideas investigating the act of drawing, repetition and manipulation of the paper surface.

Through repetition, Bowes explores the balance between two experiences of time, between an active moment and an extended period of time. She is interested in how the act of repetition allows for contemplation, but also provides a sense of comfort and/or grounding. Although there is a desire to put down some roots and settle down in one place, circumstances have not allowed for this. Bowes has found this sense of place in her work, where she is able to allow many places/memories of time to coincide within the realm of thought.

SUSPENDED, 2005-2007
Knitted book pages, thread, steel pipe

KEN BUERA'S *March* is a video inspired by the redundancies of everyday life. Filmed in a print shop, it is part of a series of videos that deal with the relationships between our cultural practices and the economy that directs them. This emphasis on production has limited our time spent on play—consequently devaluing those who are unable to contribute to our economic growth. Buera's series began as an idea to explore alternatives to conventions of 'working for a living'. During this project, Buera had to get a job—first at a mass-production factory and eventually at a print shop. *March* is his interpretation of the games we play to cope with repetition and how we can find something from the same-old-same-old. The title alludes to the repetitive rhythm of sounds created by the machinery.

Ken Buera is a Calgary-based artist and a graduate of the Alberta College of Art & Design. His audio, video and collaborative works have been shown at venues in Calgary, *Open Call* at the Southern Alberta Art Gallery (Lethbridge), *Signal+Noise* (Vancouver), *D'ouest en Est* at AxeNeo7 (Gatineau, Quebec), *Video as Urban Condition* at the Austrian Cultural Centre (London, UK), and *Rencontres Internationales* in Paris. He is active in the local artist-run centre community as a volunteer and a board bember of TRUCK Gallery, and has participated in the *Sound & Vision* residency at The Banff Centre. He currently plays guitar for Flamenco dancers in Calgary.

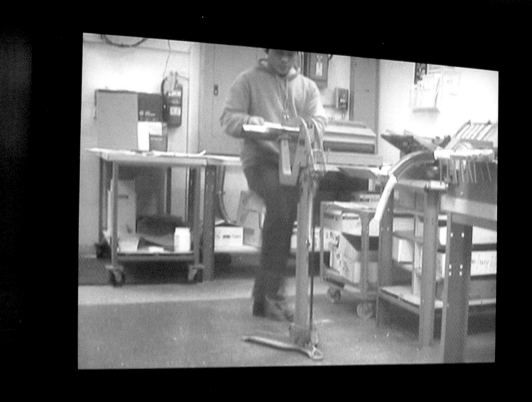

MARCH, 2005
Single channel DVD projection, auto loop

KAY BURNS is a Calgary-based interdisciplinary artist involved in the creation of audio, video, computer/electronic, installation and performance art. Burns has a strong interest in collaborative practices— she has been involved with the EMMAX collective (audio performance group) and is a founding member of the Ministry of Walking (a collective involved in the practice of walking within individual and collaborative art explorations). She is also a freelance curator and writer.

Burns' work is often site-specific and examines the relationship between humanity and place, through processes of collecting, interpreting, recontextualizing and categorizing. Sometimes the work will parody these processes as a curatorial or archival act leading to fictional/critical interpretations of information accumulation, construction and delivery systems. Aspects of acoustic ecology play a role in her work as it deals with the relationship between social, cultural and environmental elements of sonic place.

Burns' work has been presented at national and international venues, including: St. John's Sound Symposium, Struts Gallery (Sackville), Odd Gallery (Dawson City), SAW Gallery (Ottawa), Catalyst Arts (Belfast, Northern Ireland) and *Venturous Vanguard* Video Festival (Los Angeles). She recently participated in the *Imaginary Places* thematic residency at The Banff Centre and is participating in the *Elsewhere Artists* collaborative residency in Greensboro, North Carolina in the fall of 2007. She has a BFA (1985), MA (1993), and MFA (1995). She was the curator at the Muttart Public Art Gallery from 1995 to 1999. She currently teaches in the Alberta College of Art & Design's Media Arts/Digital Technologies program.

Photographs p26: Pamela Clark

CONVERSE, 2006
Interactive audio installation

CHRIS FLODBERG was born and raised in Calgary, Alberta. After completing his BFA at the Alberta College of Art & Design, he went on to pursue an MFA in painting at the University of Alberta. Chris taught painting and drawing at the University of Alberta both during and after his degree and was later hired as a drawing and painting Instructor at the Alberta College of Art & Design. Flodberg now lives and paints full-time in Calgary; showing his work there and also in Winnipeg.

Flodberg writes: "The concept of pleasure seems to be a unifying theme throughout much of my work. While it is possible to read my paintings as criticisms of excess, I think a great deal about how pleasure and guilt often accompany each other. There is always that which we want, and a price that is being paid for it. Sometimes this dichotomy is more overt in some paintings than in others."

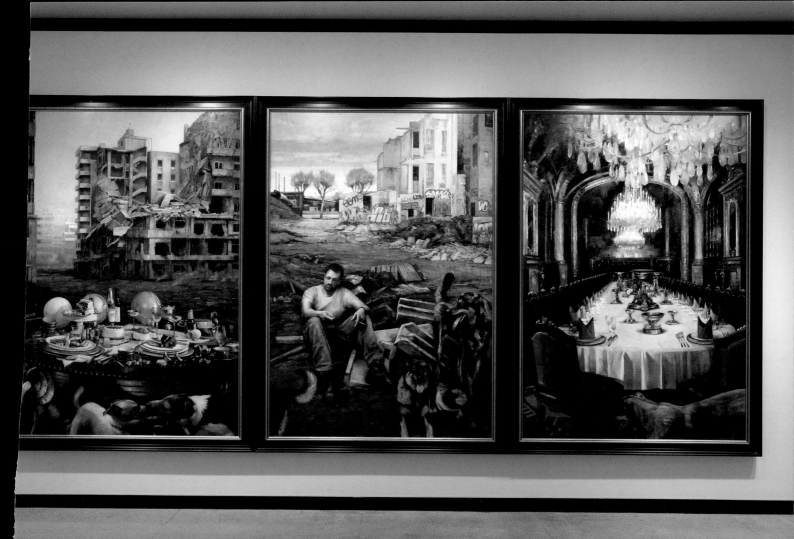

RECOLLECTIONS OF A TRIP TO PARIS, 2007
Oil on canvas
opposite: details of panel 3 and panel 1

JULIAN FORREST received his BFA from Mount Allison University in 1995, and his MFA from the University of Alberta in 2005. He is a three-time recipient of the Elizabeth Greenshields Foundation Award, and his work has been exhibited in public and private spaces across Canada. Forrest is currently a member of the Fine Arts Department at the University of Alberta (Augustana Campus).

Forrest's painting practice focuses on the figure as represented in popular culture, with a particular interest in mythology and male behaviour. His most recent project, three of which were included in the *2007 Alberta Biennial of Contemporary Art*, involved the creation of a series of large paintings of Canadian and American soldiers. These images were based on photographs found on Internet rating sites like www.hotornot.com, and are about examining public displays of the self.

 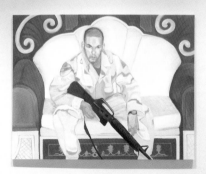 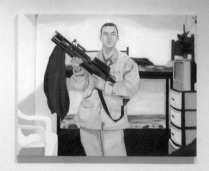

above: installation, from left to right *KILLER WHALE*, 2006
Oil on canvas
COUCH, 2007
Oil on canvas
BLUE TV, 2006
Oil on canvas
opposite: detail of *KILLER WHALE*, *BLUE TV*

PAUL FREEMAN received a BFA in Interdisciplinary Studies from the Alberta College of Art & Design in 1998 and was awarded the Governor General's Award for Academic Excellence. As a student Freeman developed a practice generating original images on a colour copier and skills as a designer and jeweller.

Before receiving an MFA in Drawing & Intermedia from the University of Alberta in 2005, Freeman provided instruction and support in art making to children and adults as well as adults with mental illness and mental handicaps. As the founding artist of Edmonton's Nina Haggerty Centre for the Arts, Freeman was able to bring his 10 years of experience in rehabilitation, as well as his fine art training and teaching philosophy, to the creation of an art centre for adults with developmental disabilities where he has worked and participated in special projects since its inception in 2003.

The drawings in the *2007 Alberta Biennial of Contemporary Art* evolved from his practice of making images from life using scanners and cameras, as well as through the use of traditional drawing technique, and his sculpture practice where bricolage is used to reconfigure or alter found objects.

Freeman writes: "The themes I am exploring are transformative and centre on the body and mortality. My interest is in the flux created by regeneration, metamorphosis and mutation. These themes, which have

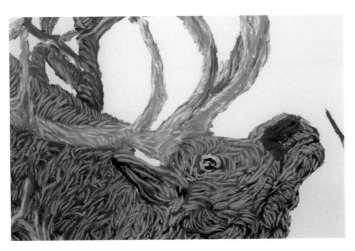

always been a subject of art, (human animal hybrids in Paleolithic art, Ovid's *Metamorphoses*) are informed in my new work by the transgression by contemporary science of perceived barriers between genders, species or kinds of living things, entities that were formerly considered distinct and absolute. My intent is to probe this uncertainty created by the new science."

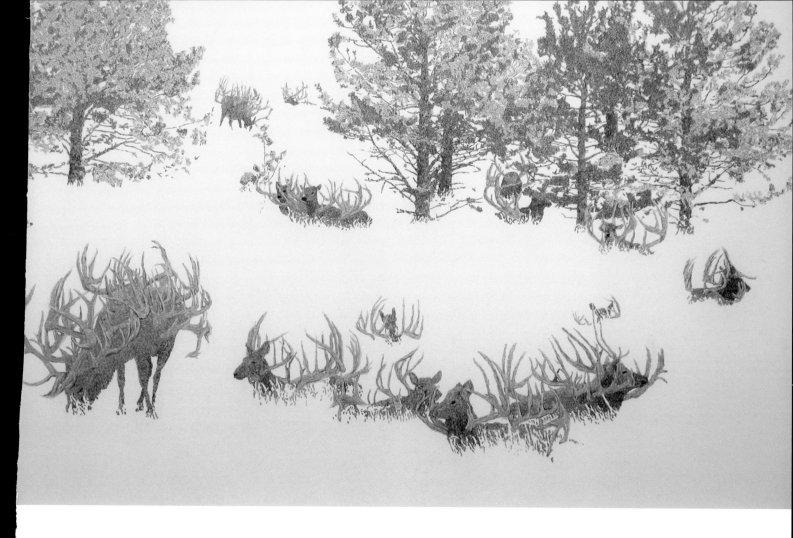

above: *Cervus Contemplus*, 2007
Pastel on paper
opposite page: detail of *Cervus Ejectus*, 2007
Pastel on paper

ANU GUHA-THAKURTA earned her BFA in Fibre (with distinction) from the Alberta College of Art & Design in 2002. Soon after, she interned as an art instructor/ literacy facilitator for a children's library organization in Ghana, West Africa. This resulted in the co-curation of an exhibition of Ghanaian children's art at Winnipeg's Mennonite Heritage Centre Gallery. Her first solo exhibition, *Provenance*, was presented at the New Gallery (Calgary) in 2005. She has exhibited in several group shows. Her work uses textiles, drawing, performance and sculpture to explore social issues, handwork and her strong interest in relational aesthetics. She lives and works in Calgary.

The two works, *Absentia (May 11, 2006 -)* and *Absentia (June 16, 2005 -)* are, in a sense, ancestral portraits of the artist's grandparents. They explore the tensions between presence and absence, permanence and transience, memory and the complexities of memorializing a loved one.

Guha-Thakurta writes: "I have carefully pinned the junk drawer to the wall, these remnants suddenly precious. These seemingly worthless bits of ephemera are not just reminders of you or things you have

above: *ABSENTIA (MAY 11, 2006 -)*, 2007
and *ABSENTIA (JUNE 16, 2005 -)*, 2007
opposite left: detail of *ABSENTIA (MAY 11, 2006 -)*, 2007
opposite right: detail of *ABSENTIA (JUNE 16, 2005 -)*, 2007
Found objects, pins, graphite

owned. They have been written in your hand, held against your body, worn out by your touch. Their presence equals your absence. It seems a raw deal, that such detritus may have undeserved, unwarranted longevity. And yet it is abrupt, surprising, your shift from contemporary to ancestor, the requisite change in verb tense, however long understood and anticipated."

Guha-Thakurta's work draws upon the social nature of cloth, as a result of its everyday and intimate use in clothing, bedding and upholstery. She states, "A pervasive concern throughout my work has been the exploration of thrift, resourcefulness through labour of the hand, and reuse versus the eagerness to consume, waste and discard that is so prevalent in consumer culture."

TERRANCE HOULE / JARUSHA BROWN

Terrance Houle is an internationally recognized interdisciplinary media artist and a member of the Blood Tribe. Involved with Aboriginal communities all his life, he has traveled to reservations throughout Canada and the United States to participate in Powwow dancing and other native ceremonies.

Terrance began his art career at the Alberta College of Art & Design in 1995, graduating in 2003 with a BFA in Fibre. He has developed an extensive portfolio that ranges from painting and drawing to video/film, mixed media, new media, performance and installation. In Canada his works have been shown in Calgary, Vancouver and Toronto and internationally in New York City, France, Germany, Australia and England.

Terrance has also had numerous screenings of his short video and film works, in particular at Toronto's 2004/2005 ImagineNATIVE Film Festival, 2004/2005 ImagiNation Film Festival in Vancouver and the 2004/2005 Calgary International Film Festival. In 2006 his work was screened at the Native American Film Festival at the National Museum of the American Indian (New York City).

In the fall of 2003 Terrance participated in a thematic residency at The Banff Centre focused on 34 indigenous peoples working on issues of colonization and communion. In 2006, Terrance also won the Enbridge Emerging Artist Award from the Mayor's Luncheon, City Of Calgary. Currently, Terrance works as a mentor with youth through the Métis Calgary Family Services, teaching video production and art. He also maintains his full-time art practice in Calgary.

Jarusha Brown is a freelance photographer and artist based in Calgary. Brown graduated with a BFA in photography from the Alberta College of Art & Design, winning the Board of Governors Award in 2005. Since then she has been avidly pursuing her passion for photographing people and places, by exploring different cultures from Canada, Central to South America and Europe.

In 2004 Jarusha and Terrance started working collaboratively on various photo series that speak about culture and place. The works are collaborations of Houle's performance work and Brown's ongoing fascination with documentary photography. The works are comments on contemporary Aboriginal culture and its placement within western Canada—touching on identity, placement, landscape, and social/political views, often utilizing dark humour. Their most notable exhibitions consist of *The American West,* Compton Verney Gallery, Warwickshire, England, *World Upside Down*, Walter Phillips Gallery (Billboards & Bus Proj-

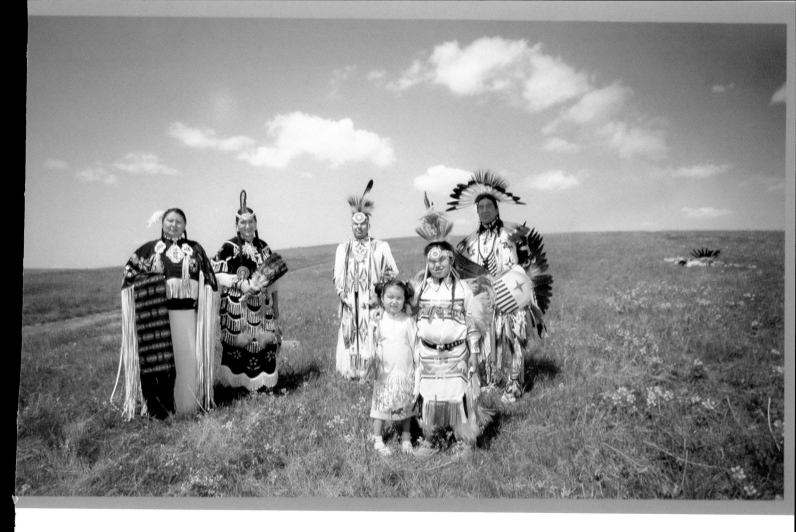

LANDSCAPE 2, 2007
Colour photograph mounted on aluminum

ects) Banff and *Out of the Dark,* WISEart Gallery, Brisbane, Australia. Jarusha and Terrance have also been featured in online & new media exhibits in Australia and the USA.

Jarusha's vision of the *Landscape* series comes to life in the expansive panoramic locations used, the simplicity of composition and journalistic approach. These combine to produce the still life sets into which Terrance's characters become absorbed, demonstrating a new way of viewing our Albertan landscape. Through the use of documentary and landscape portraiture, these works speak of past, present and future entitlement to landscapes.

above: *LANDSCAPE 1*, 2007
Colour photograph mounted on aluminum
opposite: detail of *LANDSCAPE 3*, 2007
Colour photograph mounted on aluminum

GEOFFREY HUNTER's most recent paintings continue the artist's exploration of the relationship between painting and digital media through colour, texture and surface. The first step of the process begins with older paintings or past images – sometimes historical images, sometimes the artist's own work. Through a series of underpainting and overpainting, adding and subtracting, canceling and editing, the final work emerges.

For Geoffrey Hunter, the process of painting is archeological. Archeology is the uncovering of what has been lost: all the conceits of modernist purity, transcendence and identity. The archeologist transforms remnants into treasure: the debris of civilization is categorized, named, and classified, until it finally becomes Art. These works are a conglomeration of mistakes, erasures, forgotten gestures and the debris of a visual culture found in books, manuals, science, video games, even the Internet. Similar to society's reliance on the computer, the computer has become an important tool for the artist. While the computer becomes the inward focus to a microcosmic realm, Hunter's paintings reach outward to a macrocosmic phantasmagoria. This evolution from copier, to projector, to computer has fueled Hunter's fascination with the cultural and aesthetic importance of imagery.

These paintings work within the boundary between progression and recovery, repetition and difference, loss and discovery. As an archeologist, Hunter repeats a pattern of shapes and images in order to find the ruptures within. The surfaces of his paintings are reduced to dots and carefully considered plays of colour. Hunter alternately builds then scrapes away the surface of these works to reveal the archeological intent of painting, not as object or artifact, but a search for the possibility of art.

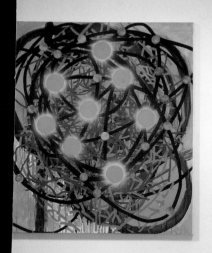 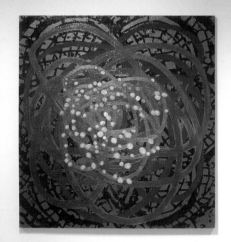 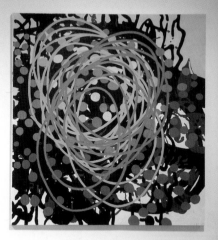

above: installation, from left to right *MOONSHINER'S DANCE*, 2007
Oil on canvas
SWIRL, 2004
Oil on canvas
HOME SWEET HOME, 2007
Oil on canvas
opposite: detail of *SWIRL*, 2004

DAVID JANZEN was born in Toronto in 1959 and moved to Alberta in 1966. He lived in Edmonton until 1979, when he relocated to Calgary to attend the Alberta College of Art & Design, graduating in 1983.

With a group show in Vancouver in 1984 and a solo exhibition in Calgary in 1985, Janzen explored conventional still-life motifs while developing ways of making pictures that incorporated assemblage or constructed elements. A small one-man show in 1986 combined these approaches. The result was a series of lumpy, shaped paintings of very small subject matter: dead insects found on his windowsills.
By 1990, Janzen's focus had shifted beyond the window panes of his studio when he found that the lamps, transformers and antennae which punctuated his view of the skyline were a form of engineered still-life as well—presented at the tops of poles with the heavens as an ever changing back drop. He continued to look outward and upward, working mostly with what could be seen from his location, describing the ground by conveying the structures installed above it. Chimneys, hydro wires, satellite dishes, microwave relay towers and other man-made features have found their way into the work.

By raising the viewer's sightline, Janzen's imagery addresses settlement, industry, the fragility of civilization's dependence on technology, tenuously connected infrastructure(s) and the effect of human habitation on the horizon.

After living in Calgary for 22 years, David Janzen moved back to Edmonton in 2001. He occupies a studio in a hangar at Edmonton's City Centre Airport and works, part time, as an artist/facilitator at the Nina Haggerty Centre for the Arts.

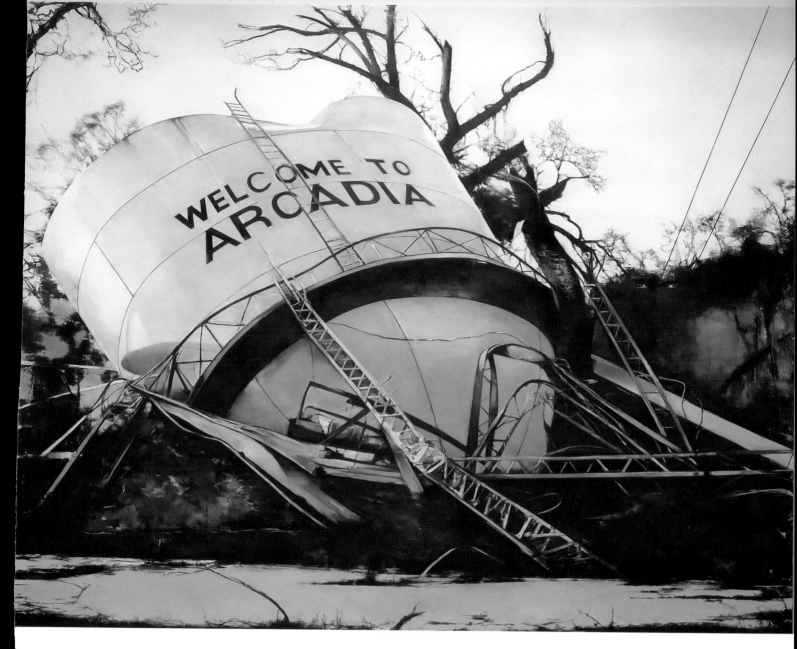

above: *WELCOME TO ARCADIA*, 2007, Oil on canvas
opposite: *LOFT (A)*; *LOFT (B)*, 2007, Oil on canvas

JONATHAN KAISER was born in Winnipeg in 1982. He lives and works in Sherwood Park, Alberta.

Kaiser's whimsical drawings and installations are conflicted as they simultaneously attempt to fulfill youthful fantasies and accommodate adult desires. While addressing timely themes that range from the very personal to the popular—including his split with Mormonism, the Canadian Gay Marriage debate, and the Alberta housing market—his work approaches new subject matter with one foot firmly rooted in the past. Convoluted biographical narratives about family relationships, anxieties, and the quest for companionship flow as subtle nostalgic undercurrents in his installations. Audience and place become central elements of Kaiser's production by influencing his choices about where and how to exhibit.

Playing with notions of exclusivity and privilege, by positioning work in a bathhouse or with pieces that inhabit only the uppermost corners of a group exhibition, he makes particular characteristics such as an individual's sexual orientation or powers of observation necessary keys for participation. Because of their resistance to opening to casual inspection, Kaiser's works are not always easy to appreciate, however, viewers who take the time to interrogate the pieces will be rewarded with secrets and fantasies abetted by Kaiser's carefully considered environments.

After receiving a BFA from the University of Alberta in 2005, Kaiser's drawings started to edge into the realm of sculpture as intertwining cut-outs. The 2005 Art Gallery of Alberta exhibition, *Draw*, marked Kaiser's first installation as the drawings began to interact with domestic objects on the gallery wall. Other recent installations in Edmonton include his contributions to the group shows *Gun Powder on Tigers' Teeth*, 2005, and *The Apartment Show*, 2007. Both of these pieces mused about alternative value systems that could be applied to homosexuality, and the imagined re-zoning of moral space in rental properties.

Lost Boys and the Hundred Year Mortgage, 2007
Mixed media installation

MARY KAVANAGH is a video and installation artist who works with Minimalist tropes such as grids, seriality, process and accumulation to produce work that explores historical narrative and modes of inscription. Her working method, rooted in traditions of archival and investigative research, follows a sustained engagement with written and oral histories, artifacts, and material and cultural residues.

Travel Notes 27.05.06: White Sands Missile Range, New Mexico, was produced from footage shot in 2006 in Southern New Mexico. The Range gets its name from the white sands that are spread over more than 200 square miles, composed of gypsum crystals that have leached out over centuries from the surrounding mountains, and that form dramatic, blinding dunes. Adjacent to the Range is the White Sands National Monument, and nearby is the Holloman Air Force Base—all clearly visible from the earth's orbit, since the area is rarely clouded over.

On July 16, 1945 the world's first test of an atomic weapon was conducted at what is now called "Trinity site", which is open to the public 2 days each year. Missile and atomic testing continues on the site at an average of 2 days a week.

A distinctive ecology survives in this 'desert within a desert,' which is astonishingly beautiful—and looks remarkably like parts of Northern Canada in mid-winter. Kavanagh comments, "I visited on a long week-end and the strangeness of the place was made more strange by the presence of many tourists—photo-graphing, sliding on crazy carpets, flying kites, sunning, picnicking, just enjoying themselves in the fantastic white landscape. The juxtaposition of beach-like behavior with the sinister history of the site's use was striking. This juxtaposition is underlined in the video piece, which presents six palm-sized video monitors, embedded like a sequence of tiny luminous windows into the wall of the gallery. Each video runs a looped series of gestures, slightly slowed. Seen together, the video sequences reflect on the tension between remembering and forgetting, on seduction, loss and survival.

Mary Kavanagh maintains her studio practice in Lethbridge where she is Chair of the Department of Art at the University of Lethbridge. She holds an MFA from the University of Saskatchewan and an MA in Art History from the University of Western Ontario. Recent exhibitions include Galerie La Centrale (Montreal), A Space (Toronto), Southern Alberta Art Gallery (Lethbridge), and the Santa Fe Art Institute (Santa Fe, New Mexico).

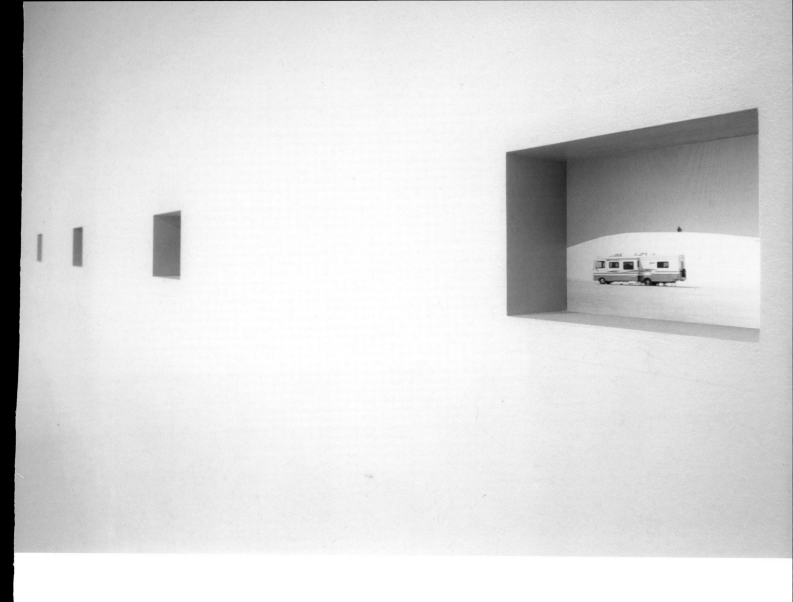

TRAVEL NOTES 27.06.06: WHITE SANDS MISSILE RANGE, NEW MEXICO, 2006
6 single channel DVDs

LINH LY was born in Saigon, Vietnam and immigrated with her family to Canada when she was four years old. She graduated from the University of Calgary with a BFA in Drawing and Photography in 1998. Since graduating she has actively exhibited in artist-run centres, and private and public art galleries, including: TRUCK Gallery, Stride Gallery, Art Gallery of Calgary and Glenbow in Calgary; Quay Gallery at Harbourfront Centre and Gallery 44 (Toronto); Alternator Gallery (Kelowna) and the Dalhousie Art Gallery (Halifax). In 2008, Ly is scheduled to exhibit at the Triangle Gallery (Calgary) and Forest City Gallery (London, Ontario) and will begin a new series of photographic work about Beijing.

The Locals is comprised of over a thousand snapshots of the dancers and participants in Calgary's electronic dance music culture. Starting at the bottom in groups of sixteen, mimicking a sixteen beat, the system of organization becomes increasingly random as Ly moves up the canvas. Constructed by hand-stitching these photographs onto canvas, *The Locals* is part of a series of 'photo-tapestries' created by the artist.

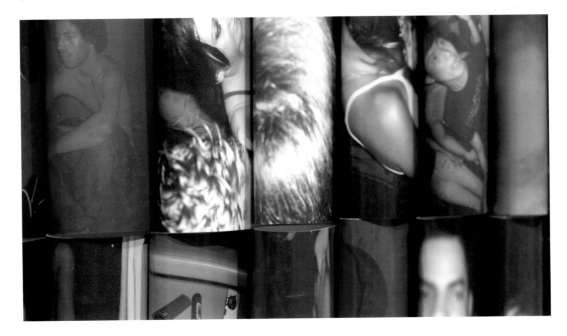

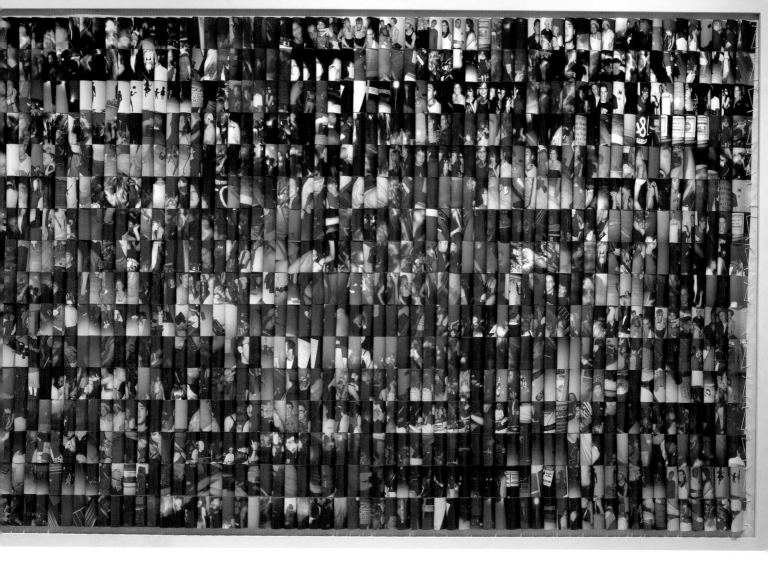

THE LOCALS, 2006
C-Prints, canvas, cotton thread

ANNIE MARTIN is a multidisciplinary artist living and working in Lethbridge, Alberta. Her art practice over the past 15 years is characterized by her parallel interests in sensory sensitivity and reading at the limits of signification, and demonstrates an evolving relationship to materials and media. Martin's concerns have traversed issues of identity and sexuality, and an interest in the circulation of material culture, toward the affective dynamics of place and environment. Recently, she has engaged with ideas of place through multiple senses, exploring the ethical dimension of perceptual sensitivity and pleasure, the blending of the senses, and the formation of a sense of self and locality through perception.

Martin states: "I see my work as experimental and speculative; I am interested in discovering through making, in setting up novel situations and experiencing the results. The ideas and material concerns within my work arise from my lived experience – the often fleeting daily encounters that defy language, have no measurable instrumental value, and which I nonetheless find compelling and wish to extend through my art. My practice consists of a series of cross-disciplinary projects that test materials, technologies and contexts in conjunction with my presence and then the viewer's. My explorations outside of the bounds of a specific artistic discipline reflect my feeling that life and experience defy categorization."

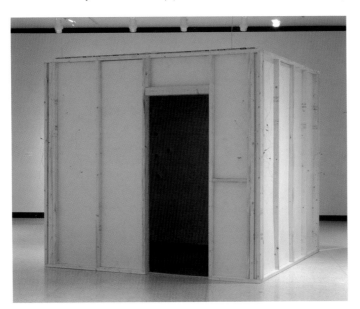

Martin's current projects include site-specific live audio installations, sound sculpture, listening walks, audio multiples for circulation, video, and fictional musical scores. Her work has been exhibited in galleries and sites across Canada and internationally. She is an Assistant Professor at the University of Lethbridge.

NERVOUS SPACE, 2007
Audio installation

MARK MULLIN received his BFA with distinction from the University of Alberta in 1991. He has studied at the Hochschule fur Bildende Kunste in Hamburg as a guest student in 1994. In 1999 Mark received his MFA in studio arts from Concordia University in Montreal. He has participated in residencies at The Banff Centre and the Cooper Union School of Art in New York. Mark has had numerous solo exhibitions across Canada, which include: Leo Kamen Gallery (Toronto), Gallery Connexion (Fredericton), ARTSPACE (Peterborough), State Gallery (Vancouver), Paul Kuhn Gallery (Calgary) and Art Gallery of Calgary. Selected group exhibitions include *Manifestation Internationale d'art de Québec* (Québec City), *Biennale du dessin de l'estampe et du papier du Québec* (Alma) and *Peinture Peinture* (Montreal). Mark was a western Canadian finalist in the 2004 RBC Painting Competition. His work is in numerous private and cooperate collections, also including The Alberta Foundation for the Arts, the Musée du Québec, and the Art Gallery of Nova Scotia. In 2007, Mark produced a series of etchings at VanDeb Editions Print Studio in New York City. Mark Mullin is currently represented by Paul Kuhn Gallery in Calgary.

In Mulin's words: "The painterly instances that comprise the works nudge at the forms we associate with microbiology, physics diagrams, graffiti forms, geometry texts and comics. Elements laced with traces of disposable culture stitched with elements considered to be the bedrock of our physical realities. The works' surfaces of incongruous elements are something like a Frankenstein's monster of paint parts whose arrangement and combination give strange life to that which shouldn't grow. The colours suggest a heartfelt belief in positivity—in joy and light and optimism—in hope. Entwined in this are the awkward nuts and bolts that may prove to be this ideal's undoing and the hint of a of pending crisis. The works teeter between a state of formulation and system meltdown; bound in the negotiation between being forever under construction and deconstruction, falling apart and coming together. The paintings' vitality results from their struggle with their own hybridity and the viewer's struggle to process the conflicting

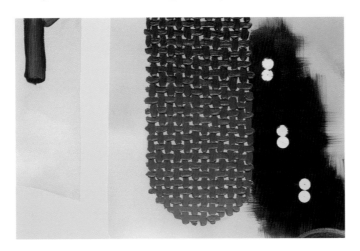

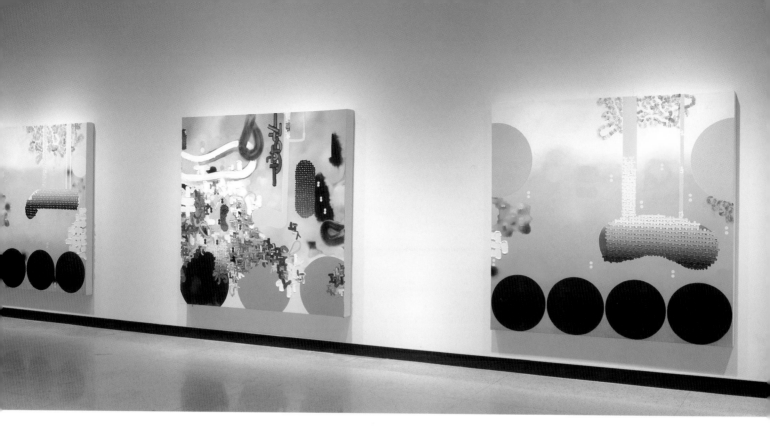

above: installation, from left to right *A GROWING TIME*, 2007
Oil on canvas
THE WEIGHT OF THINGS, 2007
Oil on canvas
ABSORPTION RATES II, 2007
Oil on canvas
opposite: detail of *THE WEIGHT OF THINGS*, 2007

visual combinations that have formed a 'new animal'. Though these works initially exude a playful glee, it comes not from a place of a belief that they can function based upon sheer painterly grafting, guts and luck. In the attempt to fashion an idealistic hope from collected bits, the seeds of potential ruin are imbedded."

PAUL ROBERT is an interdisciplinary (or maybe non-disciplinary) artist living in Calgary. His installations, sculptural objects, videos, stereoscopes and public interventions have explored the limits of language and the mind in imposing order on images or data received by the senses. Often relying on tricks issuing from the principles of linear perspective, but also colour theory, these works present perspicuous examples of cases in which habitual modes of perception fail to synthesize their disparate elements into an overarching unity.

Examples of this might include a deep space that produces an illusion of flatness, or a stereoscopic image in which vision and touch provide the mind with conflicting reports. His objects are frequently resolved at an unnecessarily detailed level geometrically or algebraically before being executed using modest, imprecise materials such as cardboard or MDF. Since 2004, he has been steadily dabbling with web programming, creating web-based projects that seek to re-iterate the question, "what is a computer?" These mimic typical web-based applications insofar as they respond dynamically to user input, but fail to serve a definable purpose, or to relate to anything outside of their own logical structure. By presenting form without content, Robert foregrounds the computer's capacity for computation, and the conventions that influence its development, future directions, and users. These projects also seek to drive a wedge between what the computer presents to the viewer (the results of a calculation) and what it pretends to present through real-world metaphors (a humanly-generated physical document).

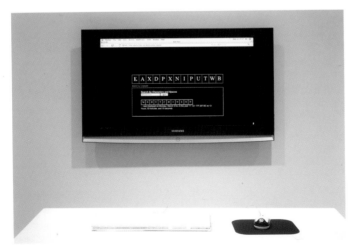

Robert began his schooling in the Fine Art Program at Grant MacEwan College in Edmonton (Diploma), continued at the Alberta College of Art & Design in Calgary (BFA), and then at NSCAD University in Halifax (MFA). He served as Programming Coordinator at The New Gallery in Calgary in 2002-2003, and has been involved with other artist-run centres in various capacities. He teaches at

EVER SINCE, 2006
Digital project and printed books

LAUREL SMITH was born in Calgary and received her BFA with distinction from the Alberta College of Art & Design in 1998. Soon after her graduation, Smith moved to Montreal where she attended Concordia's MFA program, graduating in 2001. Her minimal paintings, which reflected colour onto the walls on which they were hung, expanded the boundaries of the painting's edges. In 2004 she was chosen as the Eastern Canada Winner of the RBC Great Canadian Painting Competition.

Smith's current body of painting blends the excessive ornamentation of Rococo and a delight in the Minimal, two historical styles that are diametrically opposite. The result is a body of work Smith describes as "Ornaminimalism". The three paintings in the *Alberta Biennial* arise out of Smith's longstanding interest in the impact that privileged classes have on style and taste. As in her early works, the handmade quality of the surfaces is stressed by the build up of twenty or more glazes, and the wall beyond the borders of each painting is activated and incorporated into the final piece.

Smith has been the recipient of numerous awards including Canada Council for the Arts, Alberta Foundation for the Arts, the Sheila Hugh MacKay Foundation Award, and The Brucebo Foundation Grant. In addition to private gallery exhibitions, Smith's paintings have been shown at the Nickle Arts Museum, the New Brunswick Museum of Art, the McMaster Art Gallery, UQAM Centre de Diffusion, and the Contemporary Museum of Art in Baltimore, amongst others. She is currently represented by Peak Gallery in Toronto.

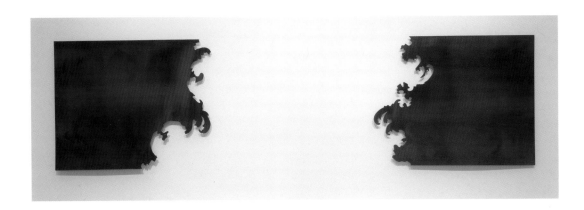

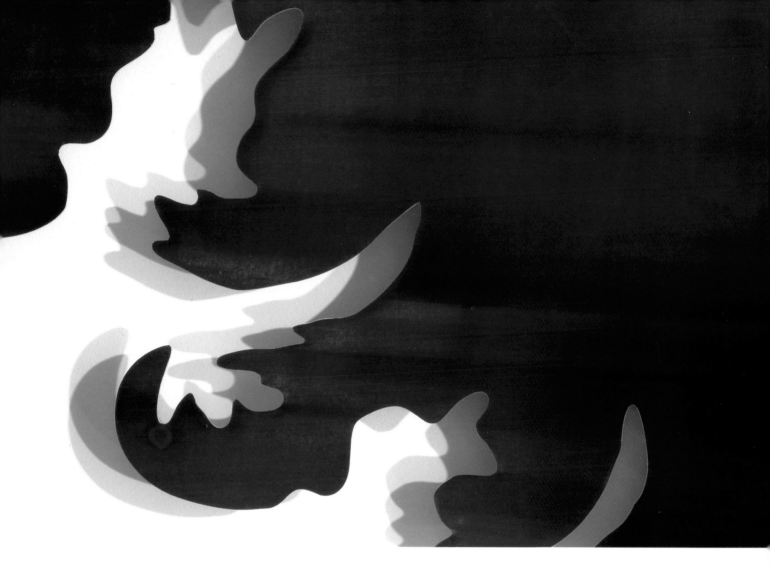

opposite: *APRÈS NOUS, LE DÉLUGE*, 2007
Acrylic on aluminum
above: detail of *MONARCHY OF THE MINIMAL*, 2007

KRISTY TRINIER was born in Edmonton, Alberta. She has exhibited sound, performance and sculpture installations in Canada, The Netherlands, Norway, China and Germany. She has received a MVA from the Dutch Art Institute and a BFA from the University of Victoria.

Kristy Trinier creates exhibitions as a system of designed conditions; the works emphasize a particular sensory response for the viewer. *Helikopter Orchestra,* 2006 is a psychoacoustics performance, documented with video and presented as a diptych. The performance is of the artist listening to sound while moving in the coordinates of space and time in a helicopter. The video records the experience of perception from two perspectives.

This project is the second in a series of psycho-acoustical performances; the first of these works was en-titled *To Listen To China For One Month Without Speaking,* 2004. The performance involved listening to pure sounds from the immediate environment without the interference of intracranial noises from speech, over a one month period. Communication occurred with gesture, eye contact and text. Listening and remov-ing the auditory masking effect of speech allows one to focus on not just the sound waves produced by the mechanics of the environment, but also those sounds produced by the ear and the brain, which are involved in the listening experience.

Through interventions that directly reflect the context of the exhibition, for example by extending the architectural or acoustic features of a space, or staging a performance that encourages transference with a viewer, Trinier's work exploits the role of perception in experiential artworks.

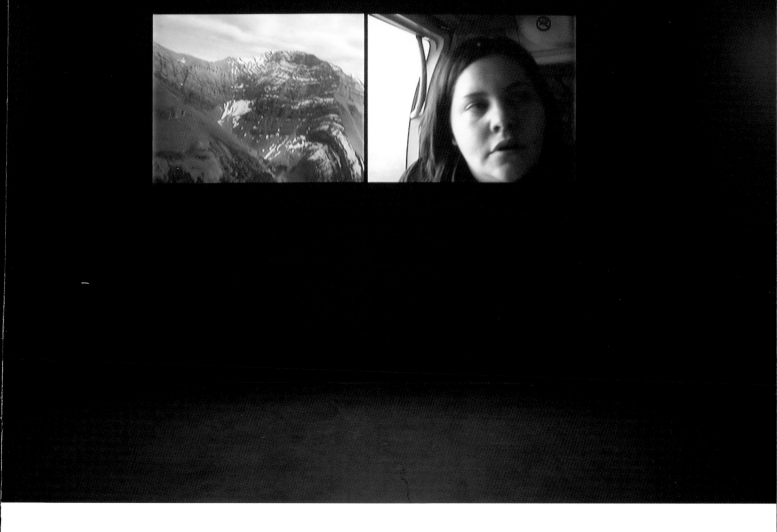

HELIKOPTER ORCHESTRA, 2006
Single channel DVD

LIST OF WORKS

Sarah Adams-Bacon

Everything Was Beautiful, And Nothing Hurt (Drawing Series), 2004
Ink on paper (36 framed drawings)
Courtesy of the artist

Robin Arseneault

Paradoxe sur le comédien, 2007
Mixed media installation (bleachers, bunting, cardboard boxes, masks)
Courtesy of the artist

Richard Boulet

CRYY, 2006
Quilting and cross-stitch
Courtesy of the artist

keeps it all neat and tidy, 2007
Quilting and cross-stitch
Courtesy of the artist

Purification, 2007
Quilting and cross-stitch
Courtesy of the artist

Jennifer Bowes

Suspended, 2005-2007
Knitted book pages, thread, steel pipe
Courtesy of the Peter Robertson Gallery, Edmonton

Ken Buera

March, 2005
Single channel DVD projection
Courtesy of the artist

Kay Burns

Converse, 2006
Interactive audio installation
Courtesy of the artist with thanks to the following people and organizations:
Curtis Burns, Marissa Hackman, Holly Schmidt, Ewa Sniatyc-ka, Rita McKeough, Shawn Pinchbeck, Peter Morgan, Kieth Murray, Joe Kelly, Jolanta Lapiak, Stride Gallery, EMMEDIA, Prairie North Residency, Gushul Studio Residency, ACAD Faculty Research and Professional Development Fund, Alberta Foundation for the Arts, The Canada Council.

Chris Flodberg

Recollections of a Trip to Paris, 2007
Oil on canvas
Courtesy of Masters Gallery, Calgary

Julian Forrest

Blue TV, 2006
Oil on canvas
Courtesy of the artist

Killer Whale, 2006
Oil on canvas
Courtesy of the artist

Couch, 2007
Oil on canvas
Courtesy of the artist

Paul Freeman

Cervus Erectus, 2007
Pastel on paper
Courtesy of the artist

Cervus Ejectus, 2007
Pastel on paper
Courtesy of the artist

Cervus Contemplus, 2007
Pastel on paper
Courtesy of the artist

Cervus Conventus, 2007
Pastel on paper
Courtesy of the artist

Anu Guha-Thakurta

Absentia (May 11, 2006 -), 2007
Found objects, pins, graphite
Courtesy of the artist

Absentia (June 16, 2005 -), 2007
Found objects, pins, graphite
Courtesy of the artist

Terrance Houle and Jarusha Brown

Landscape 1, 2007
Colour photograph mounted on aluminum
Courtesy of the artists

Landscape 2, 2007
Colour photograph mounted on aluminum
Courtesy of the artists

Landscape 3, 2007
Colour photograph mounted on aluminum
Courtesy of the artists

Geoffrey Hunter

Home Sweet Home, 2007
Oil on canvas
Courtesy of Paul Kuhn Gallery, Calgary

Moonshiner's Dance, 2007
Oil on canvas
Courtesy of Paul Kuhn Gallery, Calgary

Swirl, 2004
Oil on canvas
Courtesy of Paul Kuhn Gallery, Calgary

Endurance Part II, 2001 - ongoing
Oil on paper
Courtesy of Paul Kuhn Gallery, Calgary

David Janzen

Welcome to Arcadia, 2007
Oil on canvas
Courtesy of the artist

Loft (A), 2007
Oil on canvas
Courtesy of the artist

Loft (B), 2007
Oil on canvas
Courtesy of the artist

Jonathan Kaiser

Lost Boys and the Hundred Year Mortgage, 2007
Mixed media installation
Courtesy of the artist

Mary Kavanagh

Travel Notes 27.06.06: White Sands Missile Range, New Mexico, 2006
6 single channel DVDs
Courtesy of the artist

Linh Ly

The Locals, 2006
C-Prints, canvas, cotton thread
Courtesy of the artist

Annie Martin

nervous space, 2007
Audio installation
Courtesy of the artist

Mark Mullin

The Weight of Things, 2007
Oil on canvas
Courtesy of Paul Kuhn Gallery, Calgary

Absorption Rates II, 2007
Oil on canvas
Courtesy of Paul Kuhn Gallery, Calgary

A Growing Time, 2007
Oil on canvas
Courtesy of Paul Kuhn Gallery, Calgary

Paul Robert

Ever Since, 2006
Digital project and printed books
Courtesy of the artist

Laurel Smith

The glee of little kings, 2007
Acrylic on aluminum (dyptich)
Courtesy of the artist

Monarchy of the minimal, 2007
Acrylic on aluminum (dyptich)
Courtesy of the artist

Après nous, le déluge, 2007
Acrylic on aluminum (dyptich)
Courtesy of the artist

Kristy Trinier

Helikopter Orchestra, 2006
Single channel DVD
Courtesy of Skew Gallery, Calgary

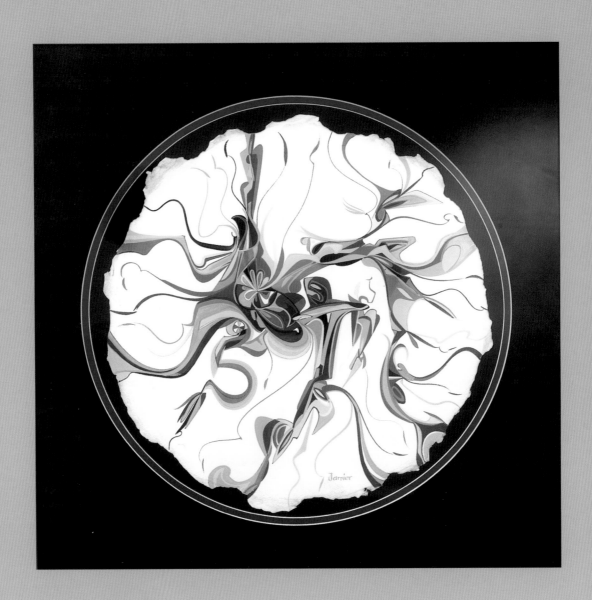

THE ALBERTA BIENNIAL CELEBRATES

ALEX JANVIER

AUGUST 31, 2007 – JANUARY 6, 2008

Curated by Donna Wawzonak and presented by the Art Gallery of Calgary

UNTITLED, n.d., Acrylic on canvas
Photograph: Keith Diamond

THE DELICATE LINE: THE PAINTING OF ALEX JANVIER
by Donna Wawzonek

In a 2003 interview with Dr. Raoul McKay, Duke Redbird refers to "the delicate line" as the trademark of Alex Janvier's painting style.[1] This turn of phrase serves as a way to understand what makes Janvier's work so distinct and recognizable and also is a means to understand the aesthetics, politics and process that give his work meaning.

The works selected for this exhibition span Janvier's career from the 1970s to the present, and follow the development and shifts in his signature style. This exhibition considers a very small selection of the thousands of paintings and dozens of styles Janvier has produced over the past 50 years. The exhibition celebrates the work of an artist who has made an immeasurable impact on the state of art in Canada.

Janvier was born on the Cold Lake First Nation Reserve, Alberta, where his father was one of the last hereditary chiefs. He spoke the Dene language exclusively until he and his siblings were sent to the Blue Quill Residential Indian School near St. Paul, Alberta. Tension between his traditional upbringing where he trapped, hunted, fished and farmed and the enforced European one where he was mistreated and confused is at the heart of his painting. This tension between the abstract and the figurative, between traditional and contemporary aesthetics and politics all play out across his canvases like a choreographed dance, led by his delicate line.

The early 1970s works in this exhibition, including *Where the Big Fish Live* and *The Warm Spell*, exemplify Janvier's painting style at this time. The abstracted forms, vegetal and animal references, and imagery from his Denesuline culture are all present in these works. Here he uses bold blocks of colour to hint at forms of flora and fauna and the patterns of traditional beadwork. Janvier's earliest memories of

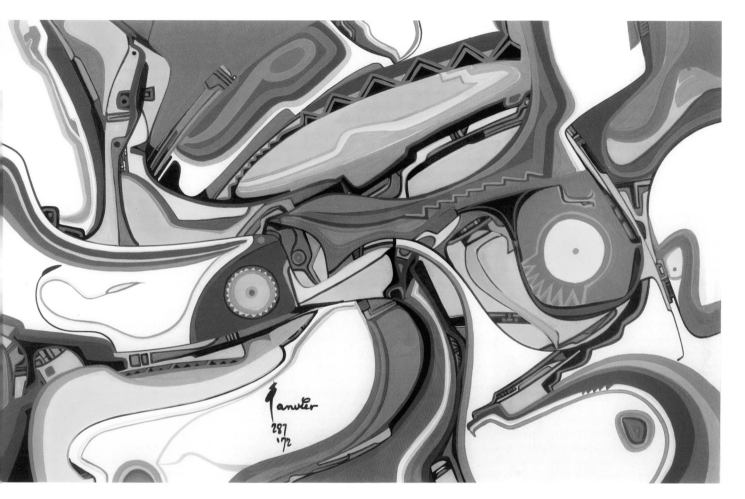

THE WARM SPELL, 1972, Acrylic on paper
Photograph: Keith Diamond

art include the works of Paul Klee, Wassily Kandinsky and Joan Miro, who all used boldly coloured abstracted forms. Janvier has been able to take these influences and combine them with the aesthetic languages from his own culture to create not a hybrid but a distinct aesthetic of his own.

Since the 1950s and his early years at the Alberta College of Art & Design (ACAD) in the 1960s until 1977, Janvier would use his treaty number "287" on many of his paintings as a sign of protest of his treatment by Indian and Northern Affairs and the Canadian government. Every aspect of his life was controlled by the government, from his enforced attendance at the Blue Quill Residential Indian School, to where he studied and what he studied and even when he was allowed to leave the reserve. It would not be until 1977 that Janvier would see himself as an individual in an immense world of millions. As Robert Houle states:

> *The elimination of his treaty band number not only signified a new direction in his painting but symbolized a coming to terms with his troubled identity. Eradication of that conflict freed his art to become the sole statement on the canvas, unbleached and more open in its composition. This changed style gave his painting a truly original language.*[2]

As Janvier's style progresses, the solid colour forms fall away and a more sparse and delicate approach emerges. *Middle East Unrest* of 1979 is a perfect example of his sense of balance, form and the interplay between political commentary and humour. *Middle East Unrest* does not refer to conflicts overseas but rather the inner conflicts of the art scene in Eastern Canada. The curvilinear forms are in perfect balance on the raw round canvas and support the complementary palette of blue spirals and the orange circular form. It is this style of work which Janvier is most recognized for. "The delicate line" is now the predominant aesthetic element of Janvier's work and represents the tension between politics, humour and beauty that are at the core of his work.

Although Janvier's work often presents biting critical commentary—such as with *Precontact Super Nature* of 1988, which refers to the devastation, both environmental and cultural, that has taken place since European contact—he also speaks

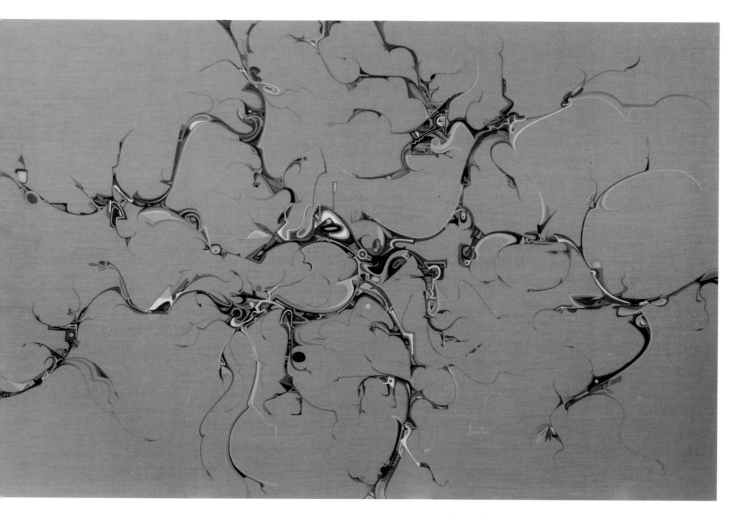

GRAND ENTRY, 1980, Acrylic on linen
Photograph © Art Gallery of Alberta

to the remaining beauty in *Alberta Rose* of 1977. Here the bright pinks and greens are a stunning representation of nature. The work is a perfect synthesis of Janvier's combination of figurative forms with his two abstract inspirations: nature and the

geometric forms of quill and beadwork. This balance is an iteration of his belief in "an indivisible contract between man and nature as equal before creation."[3] For Janvier the work makes a very clear statement: "It may be the sweetest painting of them all…In spite of the rocky, thorny life you may have, there's always an Alberta rose once in a while."[4]

Janvier's painting style is not only based on an abstracted geometry but also on an automatic painting style he developed while studying at ACAD with such notable artists as Illingworth Kerr and Marion Nicoll. The titles of the work from this era offer the viewer an entrance into its content yet the work itself is also left to the viewer's interpretation through the exploration of colours, forms and lines. The thin lines from these areas spread out like tendrils into the void of the plain canvas. As Janvier explains, "that is my language, the visual language, and I use that to convey whatever is inside me, my spirit or my feelings".[5]

In 1985 Janvier, along with Betty Goodwin and Chris Reed, was invited to take part in a cultural exchange to China, organized by the Canada Council for the Arts. China's mountainous landscape and fluid painting style inspired Janvier, and his work of that era reflects this. *Liyan Gardens* of 1986 is expressed in freer forms and we see nature represented in a new way. The strands of colour act as paths for the viewers' eyes to follow, pulling from the centre to the edge of the canvas and then swirling in again. The entire canvas becomes a beautifully choreographed swirl of motion, a dance of nature and art.

Janvier's work in the 1990s took on a more celebratory and memorial intent with his *Trapper* and *Northern Athabascan* series. The *Trapper* series, including *Ma'zeyas #18* of 1993 is a tribute to the ancestral trapping families of Northern Alberta. *Northern Athabasca* series, including *Eyak* and *Han* both of 1995 dedicates a single

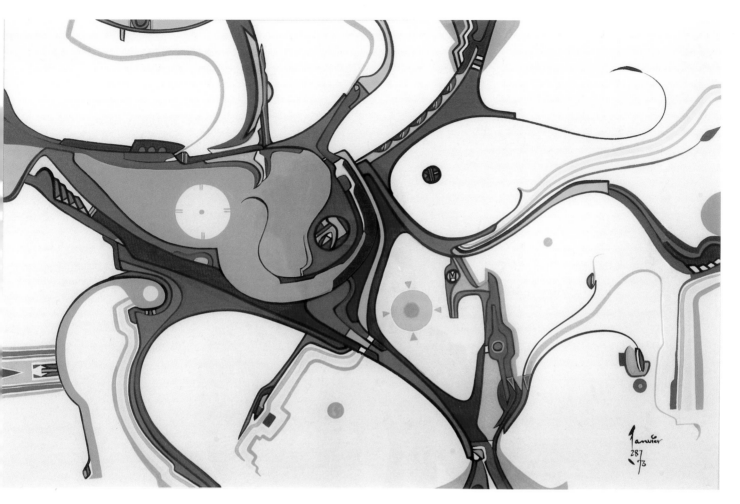

WHERE THE BIG FISH LIVE, 1973, Acrylic on paper
Photograph: Keith Diamond

canvas to each dialect in the Dene language. Each of these series is a tribute to the ancestral and cultural lines that continue to survive as well as those that have been driven to extinction.

It was also around this time that Janvier began to move away from abstraction and work in a more figurative manner. Janvier felt that this would give his paintings meaning to a greater audience. Although this new figurative style was not entirely favoured by critics and curators, in his own gallery and studio he continues to work in both his original style and many other styles that he developed and experimented with. Janvier continues to create in many different styles and modes simultaneously, firmly committed to his artistic expression rather than the tastes and trends of the art world.

Over the past number of years, Janvier has focused his work on the Primrose Lake Air Weapons Range (PLAWR) near his home where he sketches and explores. This land is at the centre of a struggle concerning land rights and environmental issues. On the side of the Canadian government is the insistence that this land has never been inhabited and is therefore free from treaty claims. On the other side are people like Janvier who see the land as part of traditional trap lines, hunting and fishing territory, and have found evidence of inhabitation. As well, there are environmentalists who are concerned about the impact of air weapons tests on the environment. Janvier, other Band members and guests have been given limited access to this site and his work in the *Environmental* series documents the natural beauty that exists there despite the activities that jeopardize its future. For the most part, these paintings represent the flowers, moss and lichen that continue to survive there. The paintings range from quite figurative work such as *Ground Less* to those that tend toward his earlier abstract style like *Moss Bed* and *Muskeg Rug,* all of 2005.

From *Alberta Rose* through *Precontact Super Nature* to his current work considering the PLAWR site, Janvier has offered us a unique look at the beauty of our natural environment that spans from succinct political statements to honour and celebra-

tion, always with an edge of humour. The delicate line in Janvier's work is one that presents a mesmerizing beauty that stings with the reality of the devastation of a land and a people. His work reflects the act of separating ourselves from nature, a state of being that Janvier considers at the root of our environmental and cultural crisis.

Notes:

1. Dr. Raoul McKay, *The Life and Work of the Woodland Artists*, 2003, First Voice Media.

2. Robert Houle "A Context for the Janvier Legacy," in *The Art of Alex Janvier: His First Thirty Years*, 1960-1990, 49-65. (Thunder Bay: Thunder Bay Art Gallery, 1993), 53.

3. McKay

4. Lee-Ann Martin "The Art of Alex Janvier: His First Thirty Years, 1960-1990," in *The Art of Alex Janvier: His First Thirty Years, 1960-1990*, 7-47. (Thunder Bay: Thunder Bay Art Gallery, 1993), 33.

5. McKay

ALEX JANVIER grew up on the Cold Lake First Nations Reserve and at the Blue Quill Residential Indian School. He studied Fine Art at the Alberta College of Art and Design and has had solo shows including *Alex Janvier: Negotiating the Land* at the Mendel Art Gallery and *The Art of Alex Janvier: His First Thirty Years, 1960-1990*, circulated from the Thunder Bay Art Gallery. His paintings are in many notable art collections including the National Gallery of Canada, the Art Gallery of Alberta and the Glenbow Museum. Janvier is to receive the Order of Canada in October, 2007.

More information about Alex Janvier can be found at www.alexjanvier.com

LIST OF WORKS

Where the Big Fish Live
1973
Acrylic on paper
Collection of the artist

The Warm Spell
1972
Acrylic on paper
Collection of the artist

Untitled
1991
Acrylic on paper
Collection of the artist

Untitled
n.d.
Acrylic on paper
Collection of the artist

Red Moss (Primrose Lake)
2005
Oil on linen
Collection of the artist

Ground Less
2005
Oil on linen
Collection of the artist

PLAWR
2005
Collection of the artist

Eyak
From the *North Athabaskan* Series
1995
Acrylic on linen
Collection of the artist

Han
From the *North Athabaskan* Series
1995
Acrylic on canvas
Collection of the artist

Moss Bed
2005
Oil on canvas
Collection of the artist

Alberta Rose
1977
Acrylic on canvas
Collection of the artist

Ground Zero #11
2005
Oil on canvas
Collection of the artist

Muskeg Symphony
2005
Oil on canvas
Collection of the artist

Muskeg Rug
2005
Oil on canvas
Collection of the artist

Ma'zeyas #18
From the *Trapper Family* Series
1993
Acrylic on canvas
Collection of the artist

Middle East Unrest
1979
Acrylic on canvas
Collection of the artist

English Bay West
1980
Acrylic on canvas
Collection of the artist

To Jackson Beardy
n.d.
Acrylic on canvas
Collection of the artist

Papal Visit
n.d.
Acrylic on canvas
Collection of the artist

High Space
1975
Acrylic on canvas
Collection of the artist

Brother's Luck
1984
Acrylic on canvas
Collection of the artist

Precontact Super Nature
1988
Acrylic on canvas
Collection of the artist

Liyan Garden
1986
Acrylic on canvas
Collection of the artist

Untitled
n.d.
Acrylic on canvas
Collection of the artist

Coffee at Stan's
1984
Acrylic on linen
Ermitano Corporate Collection

Canuck Gift Horse
1981
Acrylic on linen
Ermitano Corporate Collection

Worlds Beyond
1980
Acrylic on linen
Ermitano Corporate Collection

Hotélnéné (Muskeg Land)
1992
Acrylic on linen
Ermitano Corporate Collection

Eriahtlis Cogh (Big Book)
n.d.
Acrylic on burlap
Ermitano Corporate Collection

Old Chief
1988
Acrylic on canvas
Ermitano Corporate Collection

Great Voice
1988
Acrylic on canvas
Ermitano Corporate Collection

Environment Struggle
1988
Acrylic on canvas
Ermitano Corporate Collection

Nenni Ni
n.d.
Acrylic on burlap
Edward and Annette McCullough Collection

Garden Song
n.d.
Acrylic on canvas
Edward and Annette McCullough Collection

Untitled
1972
Acrylic on paper
Edward and Annette McCullough Collection

Beetle Country
n.d.
Gouache on paper
Edward and Annette McCullough Collection

Grand Entry
1980
Acrylic on linen
Art Gallery of Alberta Collection

Homecoming
n.d.
Oil on canvas
TransCanada Pipelines Collection

Bathing Spring Beauties
n.d.
Oil on canvas
TransCanada Pipelines Collection

ART GALLERY OF ALBERTA
Enterprise Square
100 - 10230 Jasper Avenue
Edmonton, Alberta

WALTER PHILLIPS GALLERY
The Banff Centre
107 Tunnel Mountain Drive
Banff, Alberta

ART GALLERY OF CALGARY
117 - 8 Avenue S.W.
Calgary, Alberta

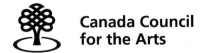 Canada Council for the Arts Conseil des Arts du Canada 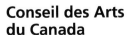 THE CITY OF Edmonton 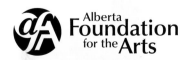 Alberta Foundation for the Arts